Flower Painting for Beginners

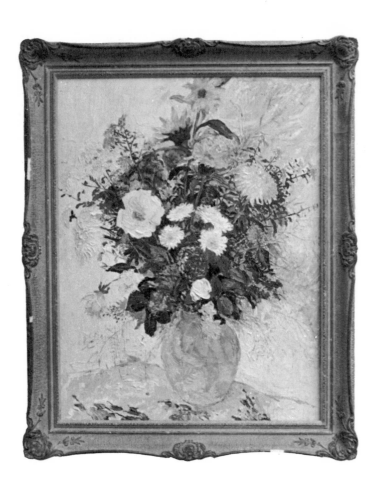

Flower Painting for Beginners

Kenneth Jameson

Studio Vista, London
Taplinger/Pentalic, New York

Acknowledgements

My thanks are due to all those students and other friends whose works appear in this book; to George Rowney and Co. Ltd for permission to reproduce part of their Oil Colour Chart on page 91; to Richard Gainsborough Periodicals Ltd for permission to quote from articles on 'Drawing Flowers' first published in *Canvas* (then *Amateur Artist*) in March, April and May 1967; to The Royal Library, Windsor for permission to reproduce Fig. 61; to the Victoria and Albert Museum, London for Figs 1 and 58; to the National Gallery, London for Fig. 60 and to the Tate Gallery, London for Fig. 62

First published in the United States in 1979 by
TAPLINGER PUBLISHING CO., INC.
New York, New York

Library of Congress Catalog Card Number: 79-84663
ISBN 0-8008-2808-9

Contents

Introduction

The appeal of flowers is universal. There is scarcely any aspect of our lives which is not touched by flowers in one way or another. We pay tributes with bouquets of flowers. We decorate ceremonial occasions, weddings, funerals, speech-days, formal platforms, with flowers. The festive table is the poorer if it is not enriched with flowers. The living room is more cheerful if flowers are present. Every shopping centre has its flower shop and the flower-seller with basket or barrow is still an everyday sight in our streets. The Victorians developed a subtle and intricate 'language of flowers'. Flowers are used as symbols—as regimental badges in the Wars of the Roses for instance, and at the present day as national emblems. It is hardly surprising that the artist pays great attention to this universal ingredient of living; but what are the practical considerations which lead some painters to devote so much of their time, energy and attention to flowers as subject matter?

Perhaps it is because the flower provides both a stimulus to fine art—the easel painting; and also limitless motifs for applied-art—carved relief of all kinds, fabrics, textiles, lace, needlework, embroidery, batik, carpets, tapestry, wallpapers, mosaics, ceramics (Dresden carried 'application' a great deal further and used three-dimensional forms of the flower motif). Folk art throughout the world draws freely upon floral motifs.

Perhaps it is because satisfaction derives from the practice and study of one aspect of art. Comprehension is deeper if study is on a narrow sector. The field of flower-painting is comfortably finite.

Perhaps it is because subject matter is always at hand, even in winter; or because there is no need for a large studio. There is a rich supply of ancillary study material in the form of books about flowers and gardens. Seedsmen will always send illustrated catalogues free of charge. Botanical gardens and gardeners' nurseries abound. Ten to one your husband or wife is a gardener and will be delighted to grow flowers specially for you, and will be even more delighted when the resulting product is set down on canvas or paper for posterity to admire.

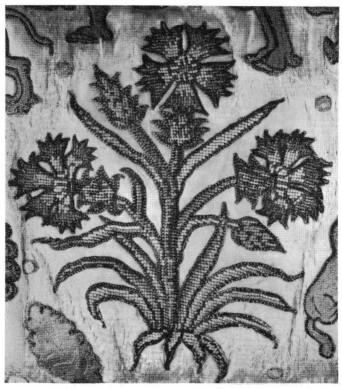

Fig 1 Cornflower, *c.* 1600. Silver thread and silk embroidery on linen.
Victoria and Albert Museum, London

We live in an age of specialisation. In every field the boundaries
have been extended so far that it is not so much a question of
whether to specialise as where to specialise. The artist is fortunate.
It is his nature to have strong personal predilections. He has no
difficulty in choosing his area of specialisation. His interests tend
naturally to lead him in one direction, and this frequently results in
exclusive concentration on that aspect of his subject which
attracts him most strongly.

The caveman used his art in a magical way, for filling his larder. The ancient Egyptians enlisted the arts in the service of the state, mainly as propaganda for dead kings. The ancient Greeks employed the artist to support their apotheosis of the human body and athletic prowess. Etruscan, Roman, Byzantine, European Renaissance Art all have their own well-known particular styles. Persian painting, Mughal painting, the Ajanta cave paintings all conjure up special visual images. Except the caveman's art, all of these include the use of flowers as subject matter or as decorative content.

Lavish publications in the form of coloured reference books of wild and cultivated flowers are an outlet for the work of the flower painter. One recalls the publication in 1965 of *The Concise British Flora in Colour* by W. Keeble Martin. The writings of the late Constance Spry and her followers in the art of flower-arranging have a good deal to say to the flower painter.

All of the foregoing has a link with the amateur's painting of a pot of sweet-peas in the local art and crafts exhibition. That link is a love of that universal component of human experience, the flower. Millions of people spend a good part of their lives cultivating flowers. The flower is used as a sentimental messenger; it is equally the stock-in-trade of big business—Interflora and such firms. Yet when all is said and done the secret of the flower and its hold over men and women is a mystery. Perhaps it is something to do with the 'personality' of these fragile ephemera— the opulence of the rose, the languid grace of the madonna lily, the innocence of the pansy, the malicious sophistication of the orchid, the drenching sweetness of the gardenia. Certainly for the painter the infinite variety in form, line, colour and pattern is a constant challenge.

If the painter can succeed in catching the perfection of the flowers at a point in time, and draw out from them their essential quality, he will stop the clock as it were, will arrest the onset of decay. He will make permanently available to his viewers a glimpse of unfading perfection.

Basic equipment

The basic equipment of the painter is more or less the same whatever his subject matter. Whether he casts his net widely, or specialises narrowly, he must still have certain items of equipment and certain supplies of consumable materials. These will vary, as between Jackson Pollack and Fantin-Latour, and between Rauchenberg and Renoir, but all painters must have:

Pigments (or other material to take the place of pigments, for instance embroidery thread, tissue paper, mother-of-pearl inlay).

A means of 'laying out' the pigments, or other materials, so that they can be selected, mixed and used, i.e. a palette.

An implement for applying the pigments to the canvas or the paper, usually a brush or palette knife (or the means to apply the threads to the cloth, ground etc.).

A device for holding the work in a convenient operating-position, i.e. an easel, table, space on the floor.

Somewhere to work.

Let us look at these under two headings: permanent equipment, which will be used time and again, and consumable materials, which must be replaced as they run out. Let us look at both groups, with the painter of traditional flower pieces specially in mind.

Permanent equipment

The most important item is somewhere to work. Ideally the painter should have a studio. The serious flower painter must have a painting corner at least. While the work is in progress, he must be able to leave everything—subject, easel, canvas, paints, brushes—exactly where they are when work stops, so that he can re-start without the frustration of having to 'set up' again. Continuity of work is vital, otherwise the thread of creative thought is lost. So begin by finding a room, or corner, which you can use. If it is inconvenient to set this accommodation aside permanently, then come to an agreement that you can use it for, say, a week every time you feel a painting coming on! A bit of ingenuity will usually solve this problem. Try the loft, the attic, the summer house, the garden shed, the cellar. Perhaps you are one of the fortunate few who have an extra room to spare. However you manage, for the serious flower painter painting space is the main problem. Because of the fugitive nature of the

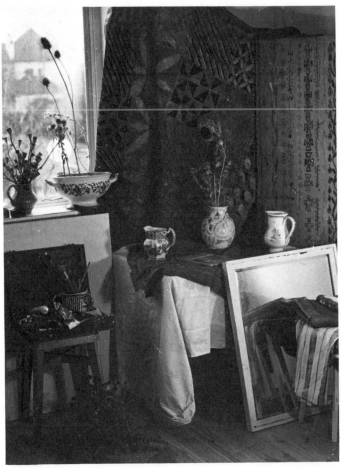

Fig 2

subject matter, flower painting calls for speedy and continuous work.

Solve this vital problem, and other difficulties will seem less formidable.

Model stand Whether you have a well-appointed studio or only a corner of the spare bedroom, you will need a model-stand upon which to place the flower groups you intend to paint. This need not be elaborate. For years I have used an old wooden kitchen table bought from an auction sale for five shillings. I sawed its legs down to give a height of eighteen inches, and tacked a 'skirting' of neutral figured material round it. I have always found that to look down on the subject gives me a composition which I find more satisfying than one made from the model at normal table height. Any piece of old furniture which has a flat top can be used as a model-stand; a couple of orange boxes (crates) with a piece of blockboard or other wood, say two feet by four feet, laid on top will also serve.

As the reader can see from the foregoing, this quite major item of equipment need cost very little. The same applies to other items, for instance:

Fig 3

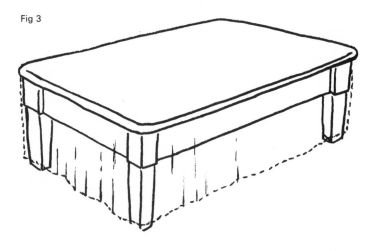

Fig 4 I always set out my palette in the same order. I keep to the spectrum sequence —red, orange, yellow, green, blue, violet—followed by the umbers, black and white. This procedure has become second nature.

Palettes Among the many different kinds of palette there are the folding type, the square and rectangular type, and the kidney shape. All may be obtained in a variety of sizes. They are generally made from hardwood and are used with oil paints. There is a somewhat wider range of palettes in enamel, glass, china or plastic, for use with water-colour and other water-based paints. Commercially produced palettes for oils are usually quite expensive. Mine, which I have used for years, cost two shillings and six pence (less than half a dollar). I bought an off-cut of $\frac{1}{4}''$ plywood, 22″ by 16″; I drew the outline of the palette and the thumbhole on it and had it cut out by a carpenter; he was also the local undertaker! This is a good shape and a good size, and it will do for either left or right-handed painters. For flower painting in oils I recommend this as a good, serviceable, hand-held palette. It is possible to buy paper block palettes in various shapes and sizes. After use, the top sheet can be torn off and discarded. This saves the work of cleaning the palette after every stint of work. I am a bit old-fashioned about this. I get satisfaction from carefully removing all surplus paint from the palette with a knife and then polishing the remaining traces of pigment off with a rag. The surface soon becomes smooth and gleaming. A well kept palette is almost a work of art in itself.

13

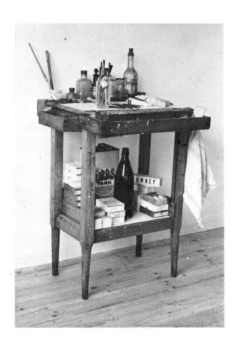

Painting-table All of the oil palettes mentioned (p. 13) are hand-held. I always keep at least one of these by me, but for work in the studio I use a table-palette, or painting-table. This again I bought for next to nothing in a sale. A painting-table has three main advantages:

1 the artist's hands and arms are left free.

2 racks can be fitted to the painting-table to hold extra paint tubes, oils, media, brushes, etc.

3 a table-top can provide a larger mixing surface.
For most of his time the flower painter works in the studio. For this reason, in my view, a painting-table should be one of his main items of equipment.

Figs 6A and 6B The top group of palettes are for use with various water-soluble paints. The plate can be used if nothing else is to hand. Fig 6B is a close-up of the mixing area on the painting-table, in use

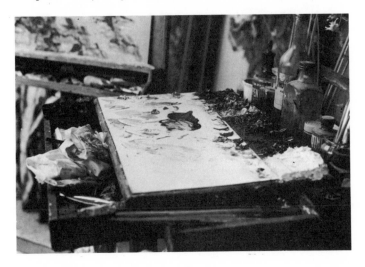

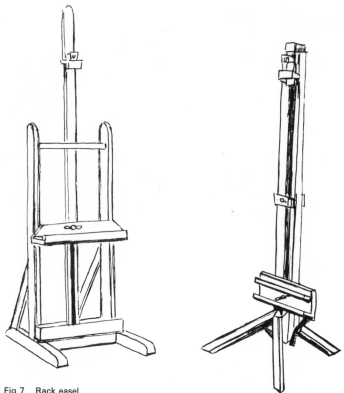

Fig 7 Rack easel

Fig 8 Radial easel

Easels The most important property of any easel is stability. It should not tip or tremble. It should be rigid enough and heavy enough to resist considerable pressure from the artist's brush. It should be adaptable enough to take boards, drawing boards, and canvases. It should be possible to adjust the height of the canvas, and it is a great advantage to be able to tilt the canvas backwards and forwards; unwanted reflections on the paint surface can be very trying and tilting will generally obviate the trouble.

Easels vary considerably in price and design. The large studio easels seem not to be manufactured these days. In any event they were very expensive. The radial easel is a good reliable design at

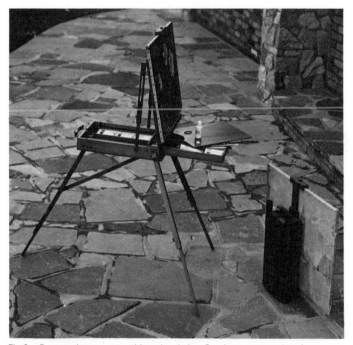

Fig 9 Box easels—narrow and broad varieties. One is open, one closed

a moderate price. The box easel is justly popular with painters, and though somewhat expensive, is really a very good investment. It is ingeniously constructed to combine a really rigid easel, a paint box with room for all requisites—paints, brushes, media—a palette and a carrier for wet canvases all in one. This remarkable compendium will, as it were, convert a normal room into a studio in five minutes. I strongly urge you to inspect one of these at your local art dealer when Christmas, birthday or anniversary presents are in the offing. One can make do for a time with a tall-backed chair, a step-ladder, a window-sill, or a shelf against a wall, but a permanent easel of some kind is a necessity. If funds are short you can make your own, or have it made for you. A suggested design and dimensions are given in Fig 10.

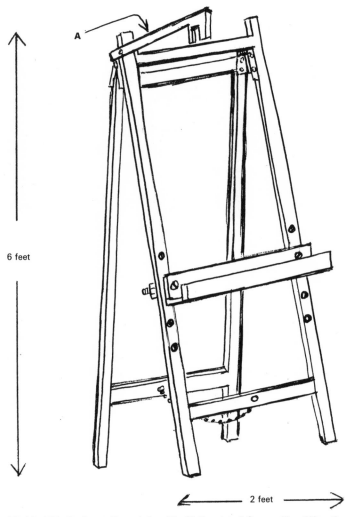

6 feet

2 feet

Fig 10 This simple easel is made from 2″ x 1″ planed deal. You need four 6′ lengths for the uprights, and seven 2′ lengths for the cross-pieces; say 40′ in all. **A** is a simple tilting bracket cut in one piece from $\frac{1}{2}$″ plywood. Two strong iron hinges, two 3″ nuts and bolts, and a 3′ piece of cord or chain complete the list of materials necessary to make it. Construction is a simple job, even for the very amateur carpenter.

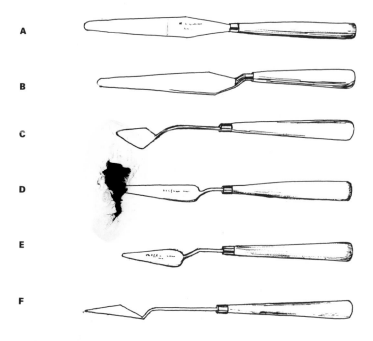

Fig 11 **A** Palette knife, straight blade **B** Palette knife, cranked blade **C** Painting knife, small pear shape **D** Painting knife, narrow trowel **E** Painting knife, narrow trowel, fine point **F** Painting knife, short half trowel. There are many more shapes to choose from

Brushes and knives The choice of brush is a matter of taste and experience. I use round-ferruled hog hair brushes, size 6 and 8, for oils; and a good sable brush, size 8, for water-colour. For oils I also use two types of palette knife; one to mix with and one to paint with. Palette knives vary very much as to flexibility, size, and shape of blade. I find it almost impossible to use some types of palette knife. Probably, in the popular phrase, it's what you get used to. Try out a number until you find one which suits you. Write to an artists' colourman (or local art supply store) and ask for catalogues. Find out what is available.

Consumable materials

Pigments Now let us turn our attention to materials. Whether we are painters in oil, water-colour, pastel, poster-colour, egg-tempera, powder-colour, gouache, or the new polymer, acrylic and P.V.A. colours; or draughtsmen in pen, charcoal, crayon, conté chalk, etc., we all need pigments. Remember that the pigments are the same in most cases; that the difference between oil paint and tempera for instance is likely to be in the binder, the substance in which the pigment is suspended. The pigments are largely the same. For instance, black oil paint, black water-colour, black tempera, black poster-paint, black gouache, black pastel, charcoal, and black conté chalk are all likely be made from the same black pigment—some sort of carbon.

As painters, we have to learn the nature the pigments and how they act one upon the other. We should know the different ways in which the pigments are made up by the colour manufacturers and the appropriate techniques for using the different colours. I shall return to the choice of colours later in the book.

Media We use the word 'medium' for the substances, mostly liquids, used to mix with colours so that they can be applied to the paper, canvas, etc. Water-colour, poster-colour, powder-colour, gouache, polymer, P.V.A. and acrylic colours may be diluted, and used, with water.

Pastel, oil pastel, charcoal, conté, and crayon need no added medium. Oil paint can be used by itself or mixed with linseed oil (and some other oils), or with turpentine, or with a mixture of both of these. I always use a 'one to one' (by volume) mixture of turpentine and raw linseed oil. Many artists' colourmen (art material shops) supply other media with special qualities, for example quick drying, matt drying, glossy drying, etc., and details are to be found in all the catalogues.

The supports This is a general term given to the materials and substances which provide the surfaces to which colours are applied—canvas, canvas-board, Daler-board, strawboard, pasteboard, panels, papers, etc.

Canvas can be bought in rolls ready-primed, i.e. treated ready to paint on. It can be bought in rolls unprimed, or stretched on frames of wood called stretchers and primed. Qualities, prices and sizes vary considerably.

Boards with canvas stuck to the surface are a substitute for canvas. They are somewhat stronger and less vulnerable to damage by pointed objects but are not much less expensive.

20

I use hardboard (untempered Masonite) primed with three coats of flat white lead undercoat paint on the smooth side. It is possible to buy non-absorbent oil-painting paper, and non-absorbent, or partially-absorbent, cardboard. You should try all these and see which suits you best.

Papers. The water-colour painter is most likely to be concerned with papers. He can choose from a vast variety: absorbent, non-absorbent, smooth, medium, rough, white, coloured; paper for drawing in ink, pastel and the rest.

Structure

In the previous chapter we have considered equipment and materials, the 'wherewithal' for producing works of art. Soon we will consider the actual process of creating a flower painting, but, before we go on to do so, we must discuss the intermediate stage of planning and arranging.

Planning is essential at all stages. It is necessary to plan what colours and equipment we will buy; what boards or canvas and the rest. It is necessary to plan which flowers are to form the subject. It is necessary to plan the arrangement of the flowers contained in the subject. It is necessary to plan the way the subject is to be arranged on the canvas. This arranging and planning is called 'composition'. Composition determines the structure of the final work. Structure is of vital importance to the process of creating a picture. If you take great care about the composing of the vase, the book, the foreground, the mirror and the blooms within the frame, this is to say that you decide the 'structure' of the work of art.

Thus, in one sense, 'structure' means the composition of a picture. But there is another meaning in the context of flower painting. I refer to the structure of the flowers themselves.

It is clear that the lupin is quite different in form and shape from the single marguerite (daisy) or cornflower. This is a difference in structure. The flower painter must be familiar with the structure of flowers. The best way to study structure is to draw flowers. I believe that the structure of *any* subject—whether it be flowers, the Sistine Chapel ceiling or Graham Sutherland's portrait of Sir Winston Churchill—is best explored, and made manifest, through drawing. It is by drawing that the different characters of flower are established. Structure is expressed by analytical drawing and careful observation of basic forms.

The reader will not make the mistake of thinking that because in this book we are concerned with painting, drawing plays no part. Drawing and painting are inseparable. While you are painting you are drawing. Colour is paramount, but it is the sensitive quality of the drawing in paint, or whatever medium is being used, which establishes the flower-like quality of the work. Your aim should be to capture the essential fragility of the flowers and to portray their individual qualities.

It was Cézanne who said that the whole of our natural and man-made environment can be interpreted in terms of a few geometrical forms. This is true. A house is a cuboid form with a prism, or pyramid, on top—and so on. The processes and

Fig 12

problems of drawing are the same whatever the subject. All flowers, however complex or subtle their forms, can be analysed, simplified, and stated as basic form. Let us look at the basic structure of one or two flowers. Perhaps it will help if we begin by establishing that there are two main groups, and by taking a look at an example of each. For reference let us call the first group the Simple flower and the second group the Compound flower.

In the simple flower the visual effect is produced by one main form. Let us take the daisy family (Fig 13) as our example— michaelmas daisy, marigold, cineraria, marguerite, aster, pyrethrum, sunflower, scabious and the rest. (I am of course writing as a draughtsman, not as a botanist! I use the term 'daisy family' only in relation to the shape, not to the generical specification.) In all of these, there is a common, simple form—the shallow cone. There are myriads of daisies in existence and no two are the same. All are based on the same simple shallow cone form, and yet all deviate from that form in their own unique way. Some petals curve forward, some backwards. Some petals group together, some remain single. The number of permutations is infinite.

Fig 13

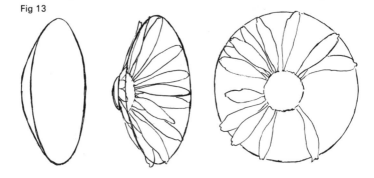

Fig 14

This drawing is very free in style. It is, nevertheless, subject to the firm discipline of the simple daisy-form of the flowers. Without this discipline the drawing would disintegrate.

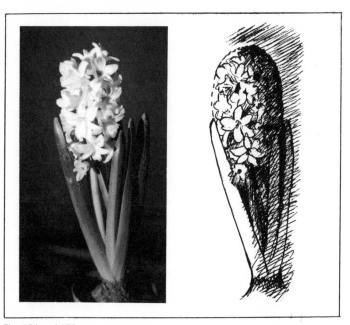

Figs 15A and 15B

The compound flower comprises a central stem and a mass of flowerets, each with its own form, grouped round it, and varies according to species. The effect of the mass of flowerets round the central stem is to produce a 'resultant' form. Fig. 15A shows a compound flower form, a hyacinth. The basic form of the floweret is a modified cone, in reality a bell-shape. The over-all form of the total flower is an elongated ovoid (Fig. 15B), and a drawing or painting of this form must take account of how it is affected by light, shade, tone, perspective and the rest. Other examples of compound form similar in structure to the hyacinth are buddleia, laburnum, lilac, lupin, delphinium.

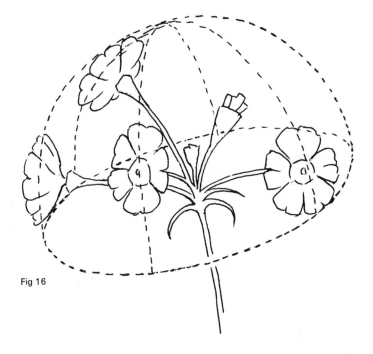

Fig 16

Variations on the compound theme are geranium, primula (primrose), hydrangea, phlox. You will be able to think of many more. These plants carry a compound flower at the end of a long stem. The flowerets are simple shallow cones and they mass together to produce a hemispherical form. The primula (primrose) is usually sparser as to flowerets; but even if there are only three or four flowerets, the form is still there (Fig. 16). Even if it is for the most part invisible, the form still governs the drawing.

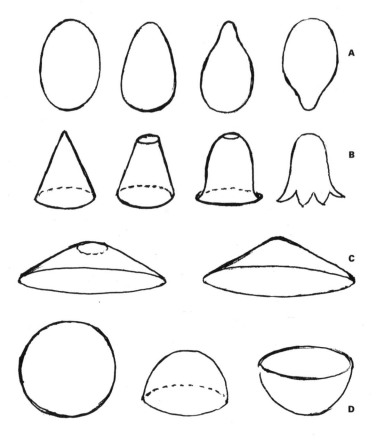

Fig 17 **A** Ovoid and variants, pear and droplet **B** Cone, trumpet, bell-shape
C Shallow cone **D** Sphere, concave hemisphere, convex hemisphere

Most flower forms, whether single or compound, can be classified
as belonging to 'families' whose basic forms are similar. Fig. 17
shows four such families.

Before leaving 'structure' we must examine that type of flower whose total form is made up from several smaller forms. The daffodil is a good example. Fig. 18A shows a breakdown of its form into three subsidiary forms, all variations of the cone. It is important to remember these three subsidiary forms are not separate. They are all parts of the total and, most important, they share a common axis. It is vital to remember that when drawing this kind of flower, or it will never look convincing or satisfactory. The fuchsia is a parallel example, with the difference that the forms are ovoid or droplet in character (Fig. 18B).

By this time my gardener readers will be saying 'All very well, but what about the sweet-pea, the snapdragon, the orchid, the calceolaria and so on?' Of *course* there are exceptions, and many of them too. Each one calls for separate study and analysis. Each study is a new experience which often surprisingly reveals new and subtle family likenesses which had not been noticed before.

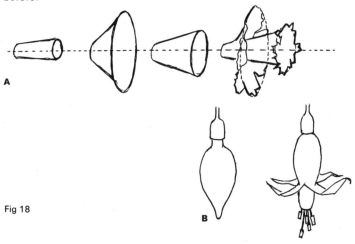

A

Fig 18

B

Before you go on to the next stage in the book, set up carefully-structured linear frameworks of the forms of such flowers as are available and draw them, as in the primula (primrose) Fig. 16. We shall take another look at 'drawing' later in the book.

Step-by-step

Now let us suppose that we have a primed canvas or board ready on the easel. The painting-table or palette is handy. Medium, brushes, palette knives, tubes of paint and clean rags, are all available.

How do we begin to marshal all these elements; to use the equipment, to apply the paint, to arrange the flowers, to place the group on the canvas, so that all may work together to produce a flower painting?

I never begin a flower painting unless I have a definite idea in my mind. I mean that I never paint for the sake of painting. I need to be 'sparked off' by some motivating factor. Let me give you two examples:

My wife is a keen gardener, and last season the garden contained, all at the same time, a number of flowers of different species, all of which were blue of one hue or another—lupin, cornflower, canterbury-bell, campanula, delphinium and others. My studio has white walls, and I suddenly saw in my mind's eye a tall narrow picture with a bouquet of blooms of various hues of blue against a white wall. The concept was visually exciting. There was a challenge, which consisted in matching, contrasting, and balancing the different blues. This triggered me off, and the picture reproduced as Fig. 64 (p. 79) was the result.

Later in the year we had two moderate-sized sunflowers in the garden. There were also some yellow roses and yellow chrysanthemums and, in contrast, some intense violet dahlias and michaelmas daisies of the same colour. I chose a large neutral-toned pot and placed the flowers in it. They formed a lively bouquet which gave me great pleasure to look at. I placed this against a gently broken background and this made it even more attractive. I felt impelled to paint it. It is this painting which forms the subject of the series beginning at Fig. 19 p. 32 and ending with Fig. 47 p. 61 in this book.

There is a school of thought which says that the student should study first and perform later—Five-Finger Exercises and arpeggios, and, much later, the concert performance of the *Emperor Concerto*. There is a parallel in some art circles, where it is advocated that the student should spend his first years studying meticulously, and proceed through a slow graduation to the production of major works.

On the other hand there is something to be said for pitching the student, headfirst, into the deep-end. Why not 'have a go', straight away? It is much more exciting than toiling away for too long on preparatory exercises. But a word of caution; do not be too disappointed if your first major effort fails, as it may do. Use it as experience. Try to find out what went wrong and avoid the same pitfall next time. *Also*, and this is important, continue with careful detailed study at the same time.

So let us take the plunge. At the end of the exercise we will analyse and discuss what we have done. Remember that the method outlined here is only one way of doing it. It is a method I have worked out for myself. It gives me what I want. It may, or may not, suit you. But I urge you to try this system. If it does not work for you, then turn to page 73 and try the methods suggested there. How you work is a matter of personality. You must select your own method of work by trial, selection and rejection.

As has been said earlier, a good part of the process of creating a picture is arranging—composing. A great deal of the work must be done before painting even begins.

Take a look at Fig. 19. It is a large group of flowers. The very first job was to decide which pot to use; which would, for instance, best accommodate that number of stems, be the most suitable colour and offer the best shape for that particular painting. Every painting is different and poses different problems. A problem in this case was that the pot was right for my purpose in every respect but one—shape. I would have preferred one with a narrower foot. You will see how I solved this difficulty later in the book. Fig. 19 shows a mixed group, and the variety consists in differences of colour, scale, texture, tone, form, structure, and the rest. Perhaps the most important single task is to make a balanced group from these dissimilar elements. Colour is a vital factor. So let us consider first how to achieve a balance of colour. My method of doing this is to make sure that the various colours are *dispersed*. By this I mean if there are several yellow chrysanthemums, I avoid massing them all together in one spot, or on one side of the group.

The same applies to flowers of other colours. It is also important to disperse the flowers according to scale. In other words, avoid massing all the small blooms together or all the large (Fig. 21).

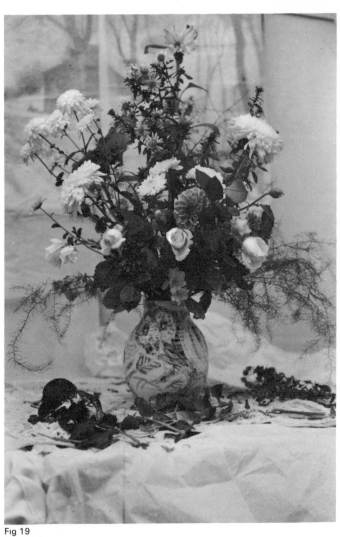

Fig 19

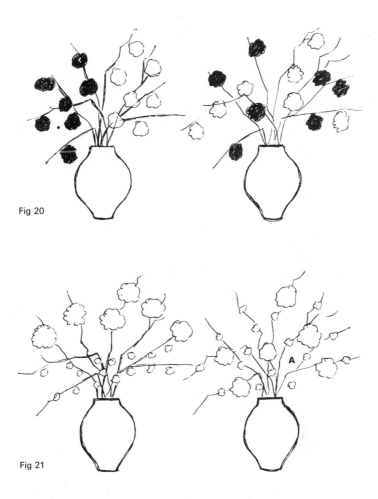

Fig 20

Fig 21

It may be that you want to introduce a special bloom into the composition; perhaps you have only one specimen. You can do this, without upsetting the balance, by placing it at a focal point such as A in Fig. 21.

If you succeed in solving the problem of dispersal and balance, then you will achieve a harmonious composition. Every part will be in place. No part will 'stand out' or be too obtrusive. Harmony is essential in a work of art. There are no rules; harmony is a matter of feeling. Imagine yourself visiting a friend's house. There is a picture on the wall. It has been jolted slightly and is hanging askew. Does it make you feel uncomfortable to look at it? If you are left alone in the room, do you feel compelled to put it straight? The picture hanging askew is 'out of harmony' with the lines of the room. The verticals and horizontals of its frame are out of parallel with the verticals and horizontals of the walls and floor. Your discomfort in this situation is a measure of your sensitivity to visual harmony.

Let us say that we are now satisfied with the harmony of the group of flowers in Fig. 19. It is placed in its setting, in this case in the still-life corner in my studio. The picture on the wall behind it was visually too aggressive, so I hung white tissue paper over it. This allowed the colours to show through, but muted and subtle—just the effect which I like. The edge of the table on which the pot stood had a sharp line along the front which made a strong shadow, so I put more tissue over the edge and pulled the lower edge of the tissue forward at the bottom. You can see this in Fig. 19. This did away with the shadow.

The next step is to study the group in its setting so that you can decide what shape the painting should be, whether square, or tall and slender, or some shape between these two. To do this I use a 'view-finder'. This is a very simple device, in fact nothing more than a piece of cardboard with a rectangular hole cut in it. I keep several by me with holes of differing proportions, viz. 2" by 2"; 2" by 3"; 2" by 4"; 3" by 5"; 4" by 5" Figs. 22A and 22B show the view-finder in use while painting the present subject. The function of the view-finder is to isolate that piece of your subject which you want to put down on paper or canvas. The way to use it is to close one eye and look at the subject, through the hole, with the other. Move the view-finder nearer to your eye and then nearer to the subject; move it gently from side to side and up and down, all the time watching the way the subject looks in the rectangle of the view-finder. You will be surprised how much it will vary; too much background and the subject will be dwarfed, too little and the composition will look congested. If the group is too much to one side, it will look unbalanced. If it is too near the top, it will look top-heavy, and so

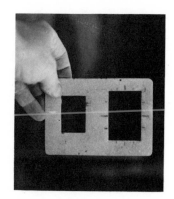

Figs 22A and 22B

on. When you have found a position of the view-finder, relative to the subject, which satisfies you, fix it visually in your mind, because *that* is your composition. Remember exactly where you were standing (chalk marks round your feet help), and remember exactly the position of the view-finder between your eye and the subject. You must be able to go back to it for checking as you work. I find the view-finder very useful for 'sizing up' the subject, and I use it while arranging the composition of the initial lines and shapes, in the first stages of work. After that I abandon it. It becomes redundant when the composition is firmly established.

Fig 23

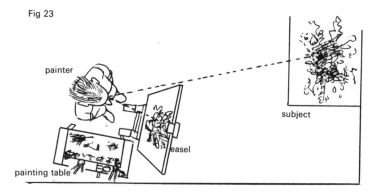

In this case, after a careful look through the view-finder, I decided upon a proportion of 3:2 and so selected a painting board sized 3' by 2', primed with white. Sometimes I paint on a coloured board. You should try it. I decide this intuitively after very careful looking. Having selected the board, I place it on the easel. The easel is placed as in Fig. 23 p. 35. This is to enable me to look from subject to painting merely by turning my eyes. There is nothing more frustrating than having to peer round, over, or under the canvas to see the subject, or having to face one way to paint and another to see the subject. This is a simple, obvious point, but experience shows that it needs to be said.

All is now ready and I take a long, close look at the subject in preparation for making the first mark. At this point I notice an area in the group, top left of centre, which appears to be somewhat empty. I hesitate. To alter it will mean a delay, but I dislike false starts. The beginning of every painting is the most difficult time. But there is no escaping the fact that an extra bloom is necessary at that particular point. I find the secateurs and go in search of a suitable flower from the garden. I find a good specimen of the rose Madame Butterfly. I like the subject better with that in place. I start again.

The preparations described thus far occupied Friday afternoon and evening. Today is Saturday. Work began at 11.00 a.m. The first consideration is the pot. Its position on the board will govern everything else. A look at the subject shows that the pot is about one third of the total height of the group. I lay-in the first lines of the pot and, as I do so, I change its shape. This is my solution of the problem I mentioned earlier. I make the foot

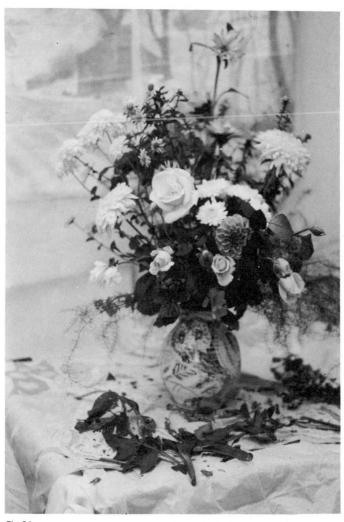

Fig 24

narrower; I prefer it that way. I would have used a pot with a narrower foot, but none was available when I was setting up the subject. Do not be ruled by what is in front of you when painting. There is only one law and that is the one which requires you to do only what is necessary to produce a good picture.

I use pencil for the first lines. Pencil line is not agressive. It does not smudge.

Fig 25

Having placed the pot, I now consider the total resultant outline shape of the group; in other words the outside edge of the mass of leaves and flowers. Taking this and the edge of the table into account, I aim to achieve a satisfying balance of shapes within the rectangle of the board upon which I am painting, see Fig. 26. I am not satisfied with this first attempt. It is too cramped, too small. It must be enlarged.

Fig 26

Fig 27

Compare this outline with the previous one. Note where the enlargements have been made. Do you agree that this is an improvement?

The outline, still in pencil, is made heavier than normal for the sake of clarity in reproduction.

Fig 28

It is important to note and to remember that the main flowers
are not drawn at this stage. They are merely indicated with a
non-committal line, in a diagrammatic way. The lines are not
'definitions', but rather indications of where the areas of colour
will be laid.

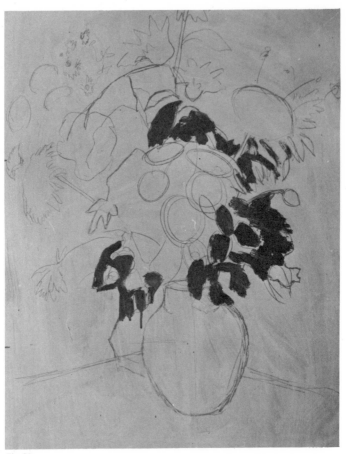

Fig 29

Work was interrupted yesterday and it is now Sunday. I begin with the 'lay-in' of the leaves. This is the first pigment to be applied. The colour is a mixture of terre verte, yellow ochre and ivory black: it is kept dark in tone and restrained in colour. It is applied with a size 6 hog hair brush.

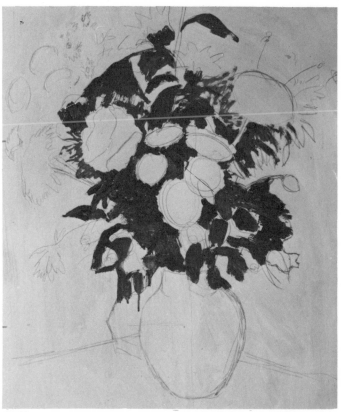

Fig 30

Further filling in of the leaf mass with the same colour, and an adjustment of the position of the Madame Butterfly rose, a move of about an inch and a half to the right. I can give no reason for this except that, after looking at it for some time, I felt it needed to be moved.

Between each application of paint I spend time contemplating, and comparing subject with painting. For me this inactive contemplation is a passive but *vital* part of the painting process.

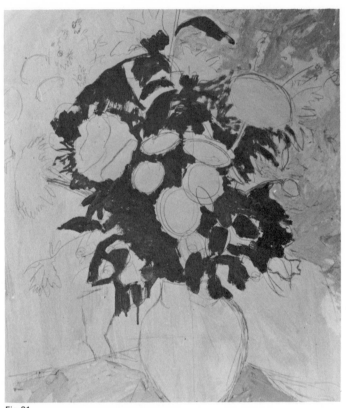

Fig 31

At this stage I feel the need to 'kill' some of the white background. I am impatient by nature and prefer to work quickly, so I use a palette knife to add grey (lamp-black and white) to the top right, and mauve (indian red, ultramarine and burnt umber) to the bottom left. Working with a palette knife is speedy. It also produces a good impasto (crust of paint). More green leaf-mass is added. Completion of this area will automatically separate out the blooms from the background and the form, or pattern, of the picture will begin to be discernible.

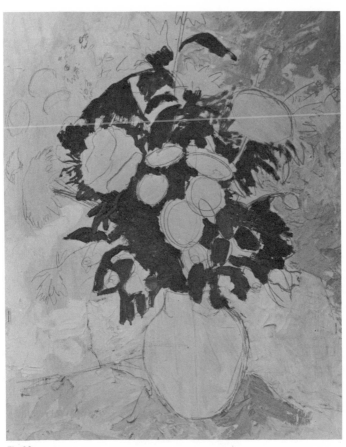

Fig 32

Areas of paint are now added, with palette knife, all over the background. I like to paint white pigment over the white ground; this produces a pearly quality of paint which, to me, is extremely pleasing. I also add a subtle grey, suggested by the tissue paper on the table-top. For the first time I become conscious of a sense of completeness, and I begin to be able to foresee the final effect.

At this stage of painting the blooms are the only areas where white board shows through, so I begin to lay the flower colours in flat patches. The large chrysanthemum on the left painted itself. Let me explain what I mean. It is a yellow bloom, deeper in colour at the centre than at the edges. In mixing the basic colours (cadmium lemon, chrome yellow and flake white), I made two heaps of mixed pigment, one matching the deeper tone, one matching the lighter. I then took a palette knife, lifted a pile of paint on the blade and placed bold curved fillets of solid pigment in the chrysanthemum area. It happened that the strokes were just right, the tones were just right. This was to some

Fig 33

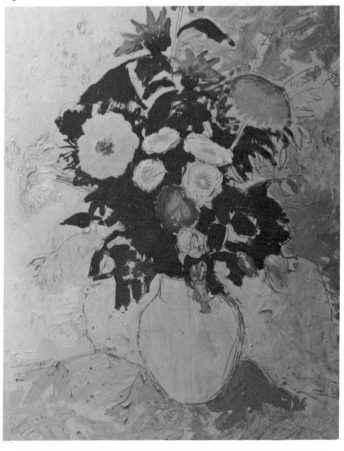

extent luck. It was a kind of fluke, one which happens sometimes and which happens more often as you become more experienced. The bloom was not touched again, at all. This was real *premier coup* painting.

At this stage of any painting I use perhaps two or three different shaped palette knives (the trowel-shaped variety are sometimes called 'painting knives'), and generally I use only one brush. I keep a small container of paraffin on the painting table, or palette, and after using the brush I wash it in paraffin each time, and pinch it dry with a piece of clean rag. I dislike using a lot of brushes. Their paint-loaded tips seem to put dabs of colour everywhere—on hands, handles, clothes. Added to that, too many brushes means too much 'washing-up' at the end of the day's session. This is a personal idiosyncrasy, but it may be a useful tip if you are one of those who likes everything shipshape and under control.

Fig 34 A loaded palette knife, showing the piled pigment on the underside of the blade

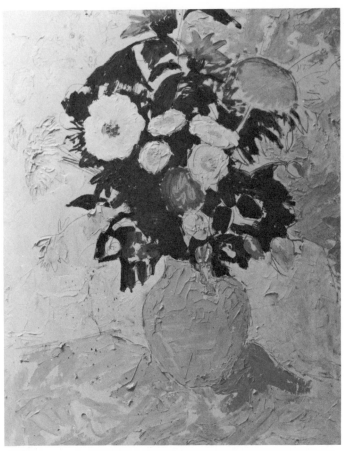

Fig 35

It is now necessary to do something about the pot. Look at the photograph of the subject again. You will see the pot is darker in tone than the background. When it is made darker in the painting it will become a shape unified with the first 'lay-in' of the bouquet, which is now complete.

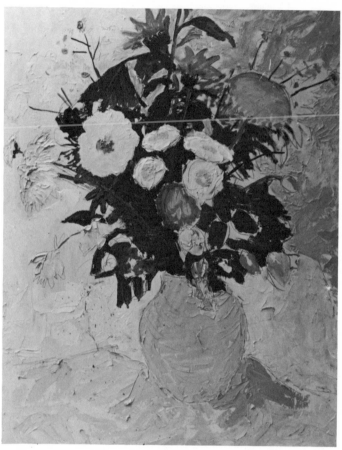

Fig 36

Having completed the pot, I am not sure that the tone is satisfactory. I will leave it a while, but I will keep looking. Do not be afraid to wait, and modify later.

I now feel the need to explore the structure of the group. What holds it together? The stems support the flower heads and the

Fig 37

direction of the stems is controlled by the opening in the pot.
I draw in some of the more obvious stems with a small sable
brush, about size 5, and fluid paint. I try to preserve the 'tension'
of the line, see Fig. 37. This term tension is difficult to explain in
words. It is a kind of tensile strength. There is nothing worse than
a flaccid drawing. A drawing which is the exact opposite of
flaccid is 'tense'. Oriental brush drawings provide remarkable
examples of the tension inherent in natural forms.

I have used the term *premier coup* before. It means, literally,
'first stroke' painting. It calls for careful analysis of the visual
material, or imaginative concept; a clear and firm decision about
the exact line, or area of colour, you intend to put down on the
board; consideration in advance of exactly how you will make
the line or area of colour; and a strong nerve in stating the line
or patch in the boldest, simplest and most economical way
commensurate with the expression of how you feel about the
subject, in one stroke if possible.

There is a correlation between *premier coup* painting and the
preservation of tension.

At this point the michaelmas daisies were beginning to fade.

The Madame Butterfly rose had opened so far that it was necessary to interrupt the routine to deal with that, before it was too late. The general framework and initial lay-in was now more or less complete, and I could begin to pay attention to the enrichment of the empty areas. Compare Fig. 38 with Fig. 39 p. 52, especially the area between A and B.

The matter of 'enrichment' is very important. It means looking minutely into the background areas, in this case the green leaf-mass, and seeking out small shapes, forms and textures. The michaelmas daisy leaves provide small 'spear' shapes. These I use for overpainting the background in slightly differing tone and colour to 'enrich' the paint. I make no attempt to *copy* what is there. I *use* the visual idea it gives me (in this case the small shapes of the daisy leaves) to add visual interest and subtle variety to the paint. Notice how the large dark leaf near A is modified and broken down, and how the whole outline is softened.

Fig 38

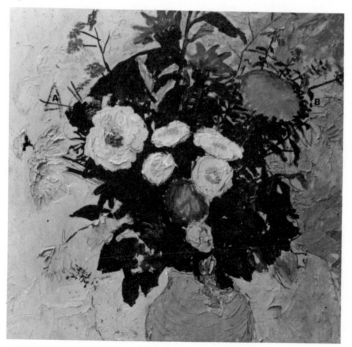

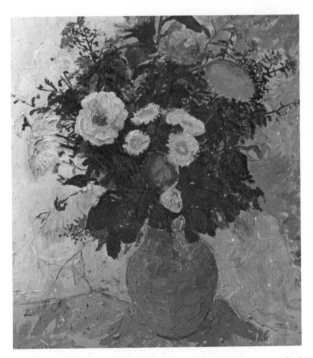

Fig 39

The process described in the previous caption is now carried out all over the painting. I look for textures, lines, dots of colour, small geometrical shapes, tone and colour variations which I can use to break down or modify the larger areas, and to provide more detail over the total mass and outline of leafage.

Note the important line of tone added, partly with pencil, partly with brush, to define the form of the pot and to lift it away from its background. As I make this modification I feel the pot is a shade too light in tone, especially on the shadow side; but the light was fading and I had to stop after six and a half hours work. Up to this point I have made no attempt to 'finish' the flowers. For me that is the most enjoyable part of the whole operation, the final reward, and, so long as the blooms do not fade, I like to keep it until the end.

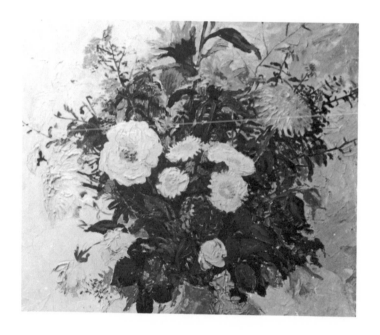

Fig 40

This is the beginning of the third day's work and, as I said yesterday, in the last comment, we have reached the enjoyable stage when all the flowers can be worked on. I begin by seeking out 'significant shapes'. I never attempt to imitate the flowers. I begin with an overall lay-in of the total two-dimensional shape of each flower. I then look for the accents produced by light. If two or three petals are 'high-lighted', I use these to provide a variation of tone in each bloom. It gives me an opportunity to add particles of brilliant pigment on top of the first lay-in—like the jewels worn with an evening dress, to give sparkle and 'zip' to the total effect. The large chrysanthemum top right shows this effect; the fillets of intense yellow pigment can be seen.

Fig 41

Look closely at this same bloom. In working on it I noted a grouping of petals along the bottom edge. This grouping produced a delicate, characterful arabesque line which would have produced a virile counterpoint against the dark green background if I had succeeded in abstracting it more sensitively. I realised I had 'missed it' but decided against working over it again. In flower painting the achievement of a quality of freshness and fragility is of vital importance and, it seems to me, this can only be achieved by the *premier coup* method. If you fall into the snare of 'messing about' too much with your oil paint, your work will lose its vitality.

Just two further notes: the drawing on this bloom was carried out with the point of the palette knife used to scratch through the paint film, and with a sharp hard pencil. The knife gave a white line, the pencil a black one.

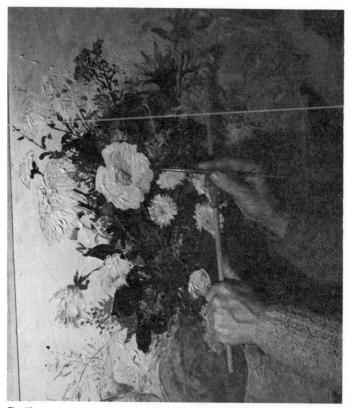

Fig 42

Second point: I was working in an awkward position where it was difficult to keep my hand steady, and I was working over wet paint, so I used a Mahl stick to rest my hand on (Fig. 42). The sunflowers at the top of the group are beginning to fade, so I now treat them in the way described previously. The mauve dahlia in the centre of the bouquet is also dealt with by darkening and intensifying the tone; the petal tips are picked out with pale mauve.

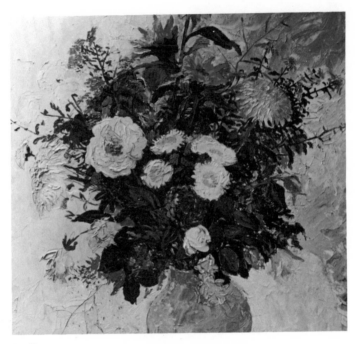

Fig 43

The painting is approaching completion now, and is becoming more detailed. The scale of the last few illustrations is increased to make it easier for the reader to see.

Darker tone is added to the pot. This is still probably not enough, but it does not worry me so much now. I will look at it again later.

At this stage I am becoming conscious of the fact that the bouquet is rather circular in form, perhaps a little too much so. This is the stage in a flower painting when many small but important considerations call insistently for treatment.

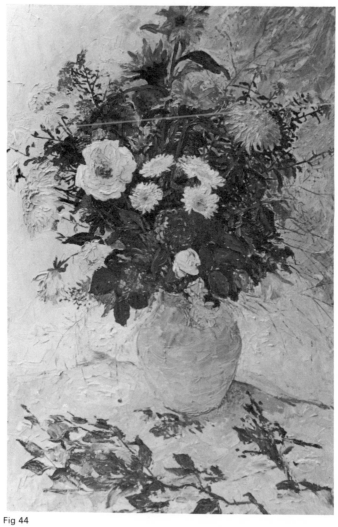

Fig 44

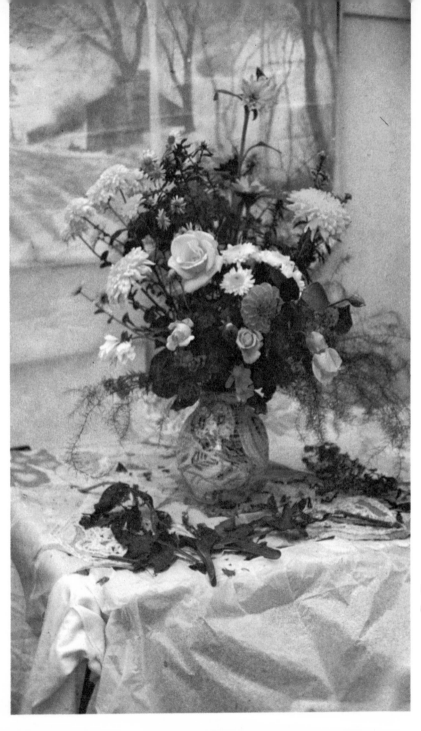

Fig 4
Fig 4

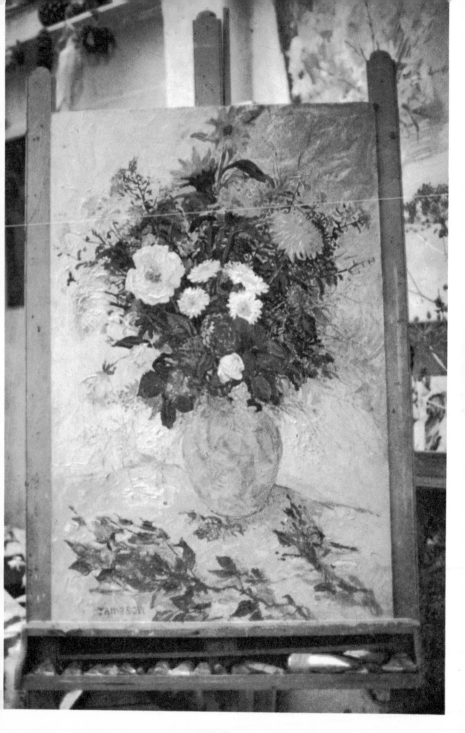

The flowers are now more or less complete, or at least all carried to the same stage. It is time now to complete the background.

As I said earlier, I like to use a noncommittal background. In this case the subject stands in the still-life corner of the studio. The pot stands on a table top over which is spread a piece of pinkish appliqué and embroidery, made and subsequently abandoned by my wife. It did not come up to her standard for exhibition purposes, but it makes an ideal 'suggestive' ground for still-life painting. Also on the table is a scattering of rose foliage not used in the group, a sheet of off-white wrapping paper with spots of pale colour, and the piece of white tissue paper, already mentioned, used to mask the edge of the table. The wall behind the flowers is white. The picture hanging there is painted in white, grey, black and mauve. This, as I have said, was too agressive behind the flowers. The two sheets of white tissue in front of it neutralised the tones and provided me with a subtle, sensitive, translatable background.

I like the background to suggest to me, not to dictate.

This is the penultimate stage. The background is covered and complete except for the addition of lozenges of colour suggested by the pattern of pale blue and green on the wrapping paper. Areas of tone are added here and there to give greater depth, especially under the foliage on the table. The fuzzy fern is put in to complete the balance of the composition to the lower left hand side. Some parts of the painting are now dry, the pot for instance, so I indicate the pattern on it.

If the reader will refer back to the previous illustration (Fig. 44 p. 57), it will be seen that there is a blank space, or at least a space somewhat lacking in visual interest, about halfway down the right side. I walk round the garden and pick a blue echinops (globe thistle). I take it back into the studio, hold it in my left hand and paint it into the empty space.

For the rest of this session I sit and look, and compare. There will be a lapse of some days before the final painting is carried out; and then the last phase will consist of long periods of brooding over the work, and the addition of small, sometimes very small, details.

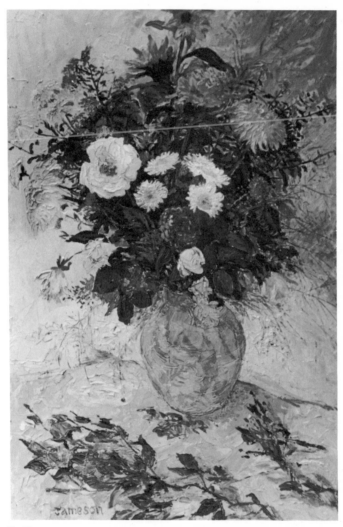

Fig 47

61

Footnote The painting was completed on a Saturday nine days after work began. It was possible to add the last details then because by that time the surface of the oil paint was dry. These details were 'points' of colour suggested by buds and leaf edges and so on which had become revealed as a result of the gradual movement of the flowers due to fading, shrinkage, dropping.

Beware at this stage not to overdo the addition of detail.

Every flower painting I produce is, really, an anthology of visual impressions, a summary of a sequence of situations. It is never a literal, photographic statement, but a collecting together of the most significant aspects of the subject, the bits which specially appeal to me.

As we have gone along I have used the word contemplation several times. It is the most accurate word I can think of to explain how I work. It means constant watching of subject and the painting as it develops; continual thinking about what has just been put on the canvas, and what should go on next. If I observe and wait long enough, the painting itself suggests the next move to me. I make it, look at it, think about it; and so it goes on.

Assessment From beginning to end the making of a painting is one long series of assessments, decisions and judgements. It is sometimes helpful to take a hand mirror, turn your back to the painting, and look at its reflection in the glass. The reversed image often reveals unsuspected errors and misjudgements in composition, tone etc. A similar effect can be obtained by standing some way from the painting with your back to it, opening your legs, bending down, and looking at it through them.

Constantly check as you go along by viewing the work with one eye closed and the other nearly closed. This will reveal anomalies in tone and intensity of colour.

Do not be afraid to ask second opinions. There is not much point in saying to your wife 'do you like it?'. Of course she will say 'yes'. Try asking her leading questions such as 'do you think this yellow is too strong?', 'do these colours go together?', 'have I done enough to this bit?', 'shall I throw it away?'. Answers to intelligently conceived leading questions can sometimes be very illuminating.

Another method of assessment which I always practise is to hang my latest painting where I can 'contemplate' it. The spot I use for this purpose is on the wall at the foot of the bed. After a few days small details reveal themselves as needing attention.

Also, if I find I can live with a painting, then I feel that, within my limits, the picture is successful.

The final version of the painting we have worked on together is reproduced in colour in Fig. 46 p. 59. It was assessed in all the ways I have indicated. I feel that parts of it are successful, but I am not sure whether I am satisfied with the effect produced by the leaves lying on the table in the foreground. I may decide to modify or even remove them. I will live with it for another week, and see how I feel then.

You will never make much progress unless you are prepared to be self-critical. Keep an open mind. Sometimes other people make very useful and helpful comments. Consider what they say, then adopt or reject as you think fit. Remember: preserve a sensible balance between self-criticism and despair.

Fig 48 This illustration shows the placing of the easel in relation to the subject. Refer back to Fig 23 p 35

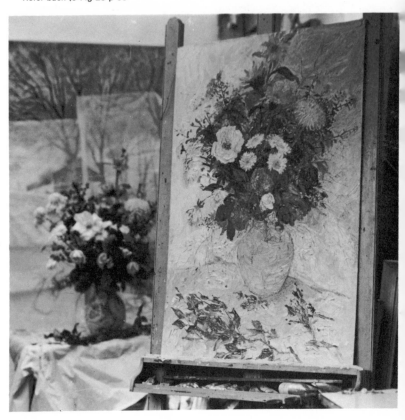

Variations on the theme

Do not allow yourself to fall into the repetitive process of producing almost identical compositions of flowers in pots one after the other.

Think back for a moment to the use of the view-finder. Take a view-finder into your local park. Visit the local flower show. Seek out interesting plants and flowers and draw them, or paint them growing *in situ* and as seen through the view-finder. Try the greenhouse, the conservatory, the local botanical garden. All these should be your hunting ground for subject matter. Nearer home your own garden, your house-plants, the cacti collection should all engage your attention.

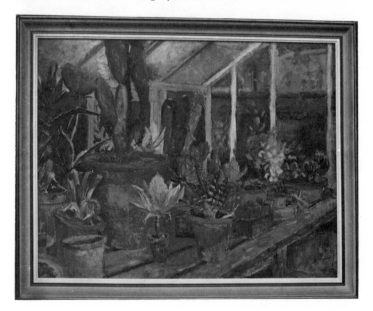

Fig 49

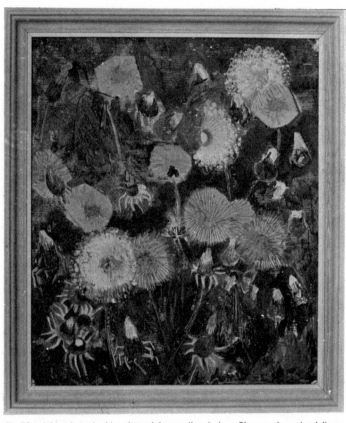

Fig 50 · A friend was looking through her studio window. She saw these dandelions growing a few feet away. An example of a subject painted *in situ*

Make a collection of dead plant-forms. Store them in the studio. Figure 51 shows a group which I have gradually collected over the last two years, and which I keep available. Study the shapes and textures such a collection can provide.

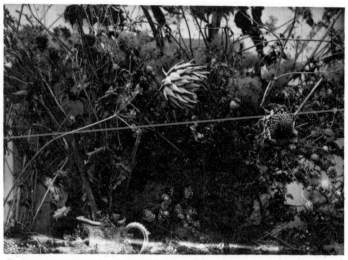

Fig 51

As well as the major variations on the theme already suggested there are many other subtle changes you can make, within the studio, on a smaller scale.

My studio walls are painted flat white. I have a number of pieces of material, varied in colour and texture, measuring about 10′ by 6′, which I use as backcloths behind the model-stand. These provide variety. For the artist who decides to specialise in flower subjects it is a convenience to hang all the back-cloths from one batten, so that they can be changed by the flick of a wrist (Fig. 52 p. 68).

Experiment with the use of a mirror in the background.

Vary the number of pots of flowers in any one picture. Why always use one? Why not two, why not five?

Talking about pots, the enterprising flower-artist will make a collection of containers. Auction sales, junk shops, antique dealers are the places to find Victorian jugs, Regency sweet-shop

glass jars, specimen glasses, moulded glass sugar basins, soup tureens whose lids have long ago been broken, majolica pots, bowls, dishes, vases, jugs, all of which provide variations. I bought the bowl which appears in Fig. 64 p. 79 for a very small sum. A perfect version of it would cost a great deal more. A couple of coats of house-paint inside the bowl rendered it watertight. The fact that it was cracked did not matter. I have developed a rewarding interest in china as a result of collecting containers for use in flower painting (Fig. 53A).

Accessories

The shape of some containers will not permit a graceful arrangement without the use of an accessory to hold the flowers. The subject illustrated in Fig. 64 p. 79 is supported by a glass 'rose' (see Fig. 53B p. 69). These 'roses' are also made in plastic and other materials. In addition there are a number of accessories available to the flower arranger. Some of these are useful ancillary equipment for the flower artist. Examples are the 'pin-holder' and wads of two-inch mesh chicken-wire (Fig. 53B).

Use as many accessories as you can find; do not be stereotyped.

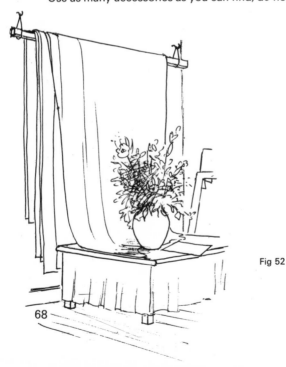

Fig 52

Figs 53A and 53B

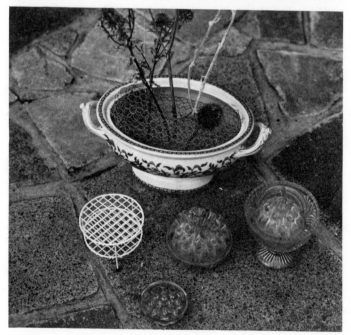

Figs 54 and 55 Two illustrations of effects closely related to our theme. The shadow of a standard rose is cast obliquely across a white wall by the sun; a bed of brussels sprouts. You *must* be 'visually curious', study this sort of thing, and take from it everything of value for your own painting. Taken literally, these two illustrations are not far removed from 'abstract art'

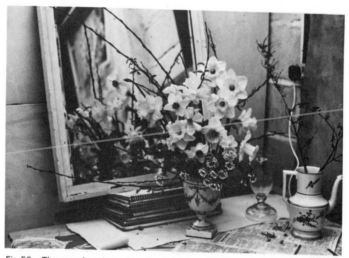

Fig 56 The use of a mirror poses fascinating problems, and adds new dimensions to subject matter

Fig 57 Indoor plants are always available. You will have to be an opportunist to catch the fleeting flower of the cactus

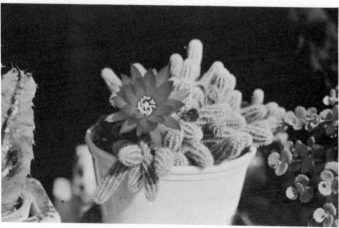

Pure or applied

In some respects the flower artist is in the same position as the mathematician. His art can be 'pure' or 'applied'. He can produce paintings of flowers which are complete and sufficient in themselves; they are 'pure' paintings. Or he can use his art to produce decorative and formalised motifs to be 'applied' to other art or craft forms – wood-carving, embroidery and mosaic, for instance. Fig. 59 p. 73 shows a formal floral motif based on a lily and suitable for use as a decorative motif. Try producing a motif like this, as an exercise; especially if you, or your wife, are interested in embroidery. Any design you produce yourself is likely to be better than the 'cliché' transfers you buy at a needlework shop.

The main concern of this book is with the 'pure' form, flower painting as such, so we will turn to some other methods of working.

Fig 58 Floral motifs figure largely in the fifteenth-century Devonshire Tapestries, a detail of clover. Victoria and Albert Museum, London

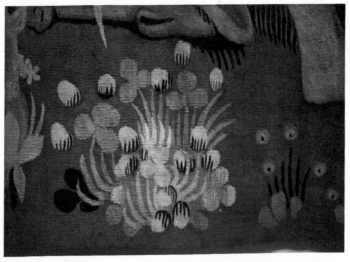

Other methods of working

Flower painting is a comparatively young art form. The first 'flower pieces' appeared in Europe (Holland notably, and France) in the seventeenth century and became popular with the artist's patron. Since then this type of picture has remained popular. Many distinguished artists have devoted much attention to it. Every student of flower painting should be familiar with the main 'schools' and the outstanding exponents of the *genre*. Study of their methods of working, and exercises based upon that study, will lead you to a fuller appreciation of the major works, and to the acquisition of a wider and more flexible technique for your own work. We will look at one or two examples.

One of the best known styles is that which was practised by the seventeenth-century Dutch flower painters. Look at Fig. 60 p. 74. It shows a painting which includes grapes, tulips, roses and other flowers. It is certain that all the items which appear in the Van Huysum picture were not available, all together, at the same time.

Fig 59 Motif abstracted from a lily

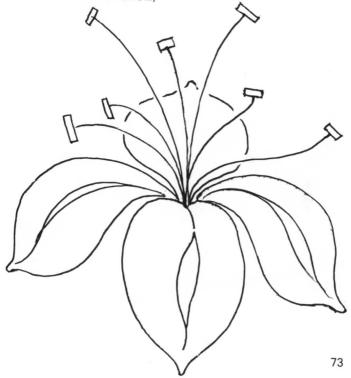

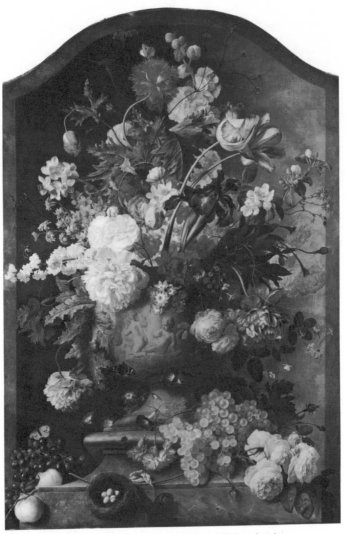

Fig 60 Flower Piece by Jan van Huysum. National Gallery, London

In other words the picture must have been built up piece by piece, over a considerable period of time, probably months. This could have been achieved in two ways: (1) as each separate flower or fruit came into season it could have been added into a carefully pre-planned composition, or (2) the picture could have been composed from previously prepared sketches, made when the items were available. These are really two variants of the same method of work; a sustained effort of planned, long-term work. I strongly commend this method to the reader as a form of practice and study. Try the following two exercises:

1 Make a preliminary working drawing. Prepare a canvas or board. Transfer the preliminary drawing to the board. Then, as flowers and fruits become available, obtain single examples of each and gradually add, week by week, month by month, each item in turn, drawing each immaculately, and placing it in the position you have appointed for it. There is great satisfaction in this system of adding a little each day. Keep on in this way until you have completed your composition.

Working in this way will not suit the impatient painter. Try it, though. It will call for self-discipline, and that will be good for you!

Fig 61 A Lily by Leonardo da Vinci. The Royal Library, Windsor Castle

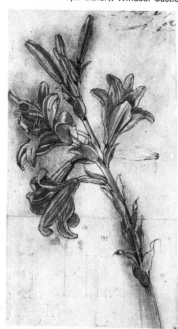

2 You cannot begin exercise two until you have a well-filled flower-study sketch-book to work from. Every serious artist carries a sketch-book, not just occasionally, but all the time. The keen flower artist should aim to make at least one study-drawing a day. If he does, he can sit down at his easel and paint a flower piece by building up from sketches and colour notes. Try this as the second exercise. Not only will it give you experience of composing a picture in this way. It will also ensure that you use a sketch-book to some purpose. Your study-sketches can be simple or detailed, small or large, in any medium. Your aim in making them is to increase your visual knowledge.

Now we will switch our attention to a painter nearer to our own time, Le Douanier Rousseau.

He painted in a formal decorative way. Metaphorically, sometimes literally, he took the flower or plant to pieces, examined its parts, ironed out all the irregularities, and took the basic shapes in their simplest form. Then he rebuilt the flowers in a highly formal and decorative way (Fig. 62 p. 77) and used them as 'motifs' to compose his picture. His motifs would do equally well for fabric design, embroidery, wood-carving etc. He is the rare kind of painter who combines both 'pure' and 'applied' art in the same style. Try the following exercise based on Rousseau's manner of working: obtain a book containing illustrations of his paintings. Study them, especially those depicting flowers, plants, trees, jungles. Then set up a group of flowers, or work from imagination if you prefer, and paint a picture in the decorative, economical way practised by Rousseau. You may find you have a flair for decorative design; who knows?

To recapitulate, we have looked in detail and at length at the *premier coup* method of working. If you will attempt the three exercises suggested above and also the method described in the Step-by-Step section p. 30 you will have four methods to experiment with and choose from. But do not stop there. Study the flower paintings of as many artists as possible. Try to understand why they are different and *what* the differences are; consider which you like and why you like them; and why others do not appeal to you. This testing of your reactions to other painters' work is a way of developing sensitivity and understanding. Try to see as much work as possible in the original by visiting exhibitions and galleries. Look out for the work of Breughel, Fantin-Latour, Van Gogh, Cézanne, Renoir, Chagall,

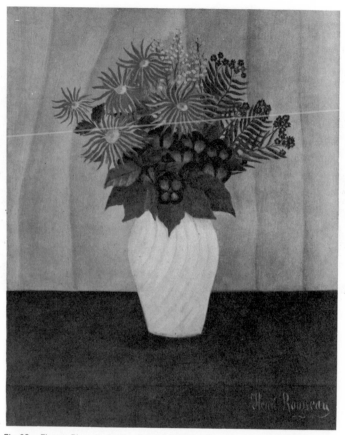

Fig 62 Flower Piece by Le Douanier Rousseau. The Tate Gallery, London

Utrillo, Redon, Matthew Smith, William Gillies, Ivon Hichens, David Jones, the early Victor Passmore, Frances Hodgkins.

Study of other painters' work is valuable in setting you thinking; but remember it is *your* reaction to flowers, *your* sensitivity to colour, *your* awareness of form which make you a painter. In other words, study other painters, but do not let their influence dominate your own special artistic personality.

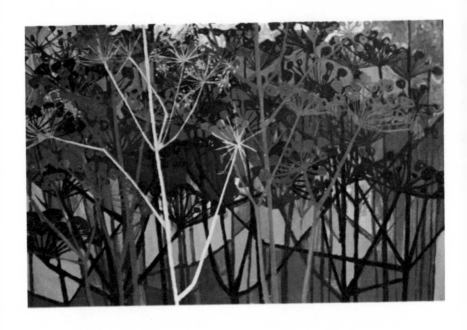

Fig 63 An *in situ* painting of cow parsley. The subject was seen *in situ* and the idea was carried away in the mind of the painter, and then painted in the studio. This is another method of working, which you should try. If you see something which gives you a strong visual experience, go back to your easel and work it out, away from the subject. The chances are that in this way you will translate rather than copy

78

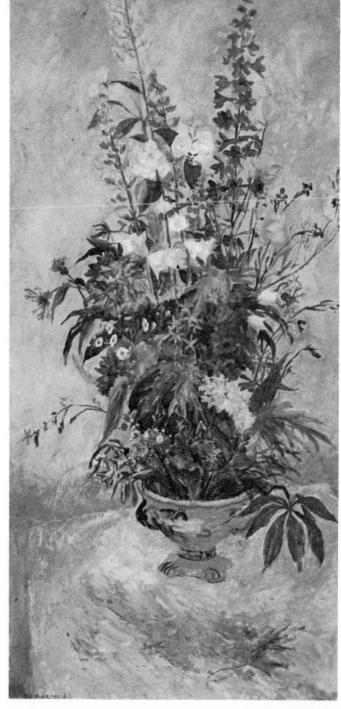

Fig 64

Drawing

Good drawing is one of the bases of good painting. So practise your drawing. It has been said before, and it will be said again, carry a small sketch-book at all times. Continuity of drawing practice is more important than quantity.

If you find drawing difficult, try the method of relating one shape to another as in the sunflower in Fig. 65. Look especially at the 'shapes between'; as for instance A, B, C, D, E. These 'between shapes' are as important as, if not more important than, the usual shapes of the flower and the leaves. Look at the large leaf F. This is an outline shape which is broken down into constituent shapes by the dissections of the veins. This powerful drawing, by a young woman artist, is a particularly clear example

Fig 65

of drawing by relating one shape to another. It also displays the quality of 'tension' which we talked about on p. 50.

Try looking round you in your home and in your garden, and see if you can spot the between shapes and how they relate to each other. Practise a few simple drawings by this method. If at first you only succeed in relating two or three shapes, this will set you off looking, and seeing, differently, and in a way specially suited to painting which is, after all, a system of relating together shapes filled with paint.

Leaf shapes have been mentioned previously; so this is a good point to say that no flower is complete without its accompanying leaf. In many cases the foliage is as characterful as the flower. Flower and leaf should be studied together as a whole. Persistent study will produce greater understanding of, and sensitivity to, flowers; and this will be apparent in your work even though you may not be aware of it.

I repeat, always carry a sketch-book. Never let a chance go by. If you see a specimen which attracts you, draw it.

Drawing any simple or compound flower form, however subtle or complex, can be approached in the same way as was the sunflower in Fig. 65. If in addition you have trained yourself to see and produce the basic formal structure of the flower which we discussed in Structure p. 22, your drawing will be that much more stable, more informed and scholarly. Learn to understand the structure. Analyse the flower forms, set up linear frameworks and then draw into them. Like all other exercises of this kind, you can soon dispense with it because the eye quickly becomes trained, and the ability to visualise the association of forms becomes part of your drawing technique.

Footnote The between-shape approach to drawing has been found to be helpful to school pupils taking school art examinations. The thesis is developed much more completely in *You Can Draw* which is published in the same series as this book.

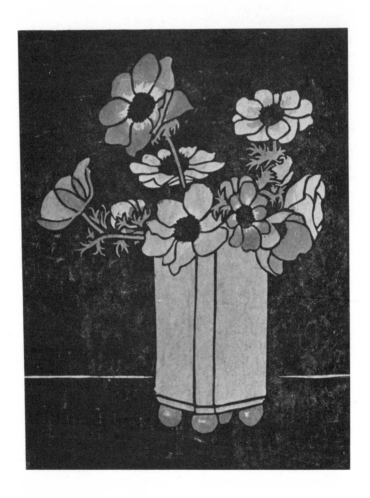

Fig 66 A flower linocut by a beginner, showing a good grasp of linear structure in the anemones

Fig 67 and 68 To me drawing means, amongst other things, exploration. The flower painter must explore everything relating to his subject—leaf forms, leaf pattern, accidental abstract shapes within the leaves—to mention only a few aspects. Exploration of structure may lead to experiment in three dimensions, as in the paper sculpture of a dandelion puff-ball head above (about 20″ in diameter)

Fig 69 A very freely drawn study of thistle and nettle. Contrast this with Fig 70 p 85

Fig 70 This study of a thistle was an essay in self-discipline; an attempt to see the shapes in relation to each other. Contrast this with Fig 68 p 83

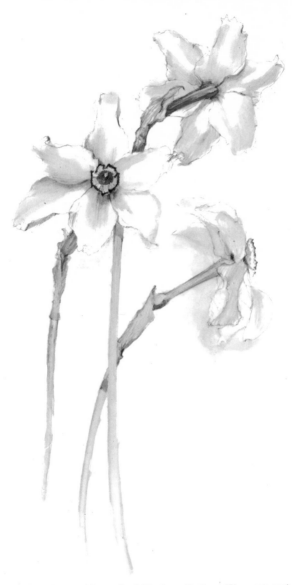

Fig 71 An exquisite study of Narcissus Poeticus (Pheasants eye) in pencil and watercolour. 15″ by 11″

Colour

Colour is a vital element of any painting. I consider it to be *the* vital element of a flower painting. You must use every means to develop your sensitivity to colour.

Colour is a visual phenomenon. For this reason I use visual methods when helping students to become aware of colour. It is better to provide the student with visual experience of colour than to present him with formulae for mixing pigments, or with theories about the spectrum, the colour circle, complementary colours and the rest. The flower painter needs to be able to see and analyse colour and to mix it as he wants it, for his particular purposes.

We will consider the 'seeing' of colour first. The following system of analysis works and can be practised at any time—on the bus, in the train, while you are out walking, in bed, in fact anywhere. Look round you now, as you read this. How many absolutely pure colours, i.e. spectrum colours, can you see? Not many I imagine, except perhaps an orange, or a flower, or a woman's dress. Most colours, when you analyse them, are greys with one or perhaps two of the spectrum colours mixed with them. Some of the greys are light, some are dark, some are in between. A tone scale as in Fig. 72 covers almost all categories of grey between white and black—light, light-medium, medium, dark-medium, dark. Take an example. Think of a navy-blue suit. Is it a pure colour? No. How would it be mixed? Which of the greys on the scale is nearest to navy blue in tone? I would say either dark-medium, or dark. What colour would you mix with the dark grey to make a colour which would match the navy blue? Blue of course. Don't take my word for it. Try it for yourself See if you can get a navy blue in this way.

Fig 72

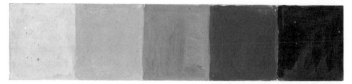

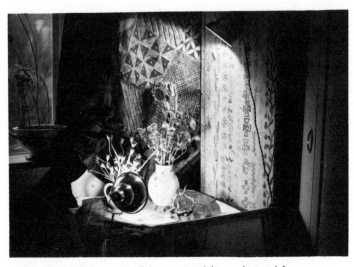

Fig 73 Subject lit by two spotlights; one top right, one bottom left

Try one more example. Do you sometimes receive letters in buff envelopes? Try analysing that nondescript colour. Apply the same questions as before. Is it a pure colour? No. Which of the greys is the nearest tone; light, light-medium, or medium? I would choose light or light-medium. What pure colour must you add to that to provide a match. Yellow. You might have to try two or three different yellows before you are satisfied that the matching is accurate.

Now launch out on your own and try matching the colour of the road outside your house, the colour of the nearest tree-trunk, the cedarwood 'lapping' on the outside of your house, your wife's hair. Go on and set more tasks for yourself. Practise both looking and mixing. When you have trained yourself to analyse and mix and match accurately and efficiently you will find you can work either with the model in front of you, or from imagination, and your colour will not be accidental, but will be securely under your control.

There is another colour exercise you should try. This one is directed to the development of sensitivity. Try the experiment of placing a white egg on a white plate on a white cloth, against a white wall. Include a white basin and a piece of white paper, a bottle of milk and any other white object which happens to be about. Then make a painting of the white group. You will find yourself involved in a fascinating problem. You will learn a great deal about white and the subtle, minute variations of one white against another; and the modifications to the colour made by direct and reflected light. Repeat the exercise with reds, blues, greens, and the rest of the colours. You will readily see the possibilities of developing this exercise.

Colour is dependent upon light. Without light there is no colour. Experiment by using a spotlight to flood your subject (Fig. 73 p. 88). Try colouring the light from the spot and see how the colour of your subject is affected. Try lighting your subject from the side, with raking light, and from the front. Try diffusing the light by masking your spotlight with tissue paper; beware of fire! Try using direct sunlight. Experiment with excluding sunlight, for instance use a north light.

Remember that colour can provide you with dramatic contrast or it can be harmonious; it can be violent or gentle. All the colours in one picture can be light in tone; this is called painting in a high key. They can be dark; this is known as painting in a low key.

Colour laid on smoothly produces a different effect from colour applied with a texture of brush or knife-strokes. Texture of paint affects tone, tone affects colour.

Choice of pigments

The range of pigments, the 'palette' of the flower painter, will vary according to the needs and temperament of the artist; but it is as well to know certain simple basic facts.

Pigments are sold in two main qualities, artists' quality and students' quality. The first are made from higher grade raw materials, are usually more finely ground, and are generally more permanent. The second are less consistent in grinding, and some of the colours are made from substitute materials and only approximate to the true pigment in colour.

I make a practice of buying the earth colours, which are usually permanent in both grades, in students' quality, and I buy the less stable colours in artists' quality. This effects quite a saving in cost.

As to colours, on balance, the flower painter may need a few more than, say, the landscape painter. I like to keep my oil palette to the fewest colours consistent with 'doing the job'. My palette is:

Reds I use three; scarlet (cadmium), crimson (alizarin), indian red (which, if mixed with white, gives a range of useful pinks). Two other pigments which are hardly reds, really, but which come in the same category, are light-red, and burnt-sienna, which gives invaluable subdued greens when mixed with prussian blue and white.

Orange chrome orange, if of good quality, is very useful.

Yellows lemon yellow, cadmium yellow middle, yellow ochre, raw sienna.

Greens terre verte is a gentle, useful, inexpensive earth green, very permanent, invaluable for harmonious mixes for foliage. Viridian is a much more intense and expensive pigment, useful for producing luminous greens.

Blues ultramarine for mixing with reds and purples, prussian blue, or antwerp blue, for making greens.

Neutrals I prefer warm colour, so I use ivory black. Flake white is my choice of white; it is a good solid lead pigment. I find zinc white too weak, and titanium too chalky. You will use a lot of white, so buy large tubes, half-pound size at least. I use burnt-umber as a staple pigment; mixed with ultramarine and white it gives me a flexible range of warm and cool greys which I find essential.

362 ***P C	354 ** C	380 ****P B	367 *
MONASTRAL FAST GREEN	HOOKER'S GREEN NO. 2	TERRE VERTE	OPAQU CHI
324 ****P E	363 ** C	643 ** C	645 *
COBALT GREEN	OLIVE GREEN	INDIAN YELLOW	ITALI
677 ****P A	667 ****P A	655 ****P C	211 *
TRANSPARENT GOLD OCHRE	RAW SIENNA	MARS YELLOW	BROW
583 ****P A	533 ****P C	523 ****P A	233 *
VENETIAN RED	MARS RED	INDIAN RED	MARS
247 ****P A	263 ** A	251 ***P B	65 *
RAW UMBER	VANDYKE BROWN	SEPIA	PAYS
5 ***P B	9 ***P A	1 ***P B	7 ***
FLAKE WHITE	TITANIUM WHITE	ZINC WHITE	FOU V

MADE IN ENGLAND BY (

Number on left of colour name is colour number
****P—Permanent. *** P—Normally Permanent. **—Moderately
Series letter at right indicates price group

Artists' colourmen (art supply stores) are always willing to send catalogues and colour sample charts. I've spent many enjoyable evenings poring over them, and sometimes as a result I have been seduced into trying out some of the more exotic of the colours. But, in the end, I always return to my all-purpose regular palette listed (p. 90).

An easy inexpensive book which deals with pigments and their properties is entitled *Simple Rules for Painting in Oils*. It is by A. P. Lawrie, and is published by Winsor and Newton Ltd. (see List of Suppliers p. 102). You would find this interesting and helpful.

Fig 74 This picture of French artichokes (found in Brittany) was painted in P.V.A.
(acrylic) colour. The great advantage of this medium is that it dries very rapidly, and
this means that several overpaintings can be carried out in one day

Fig 75 Drawing by a fourteen-year-old boy in pen made from a hollow michaelmas
daisy stem and black ink made from a domestic dye

Problems of the flower painter

The time factor

With luck a flower arrangement will remain fresh and fairly stable for three or four days, except for the very fugitive blooms which fade and fall in a matter of hours. Fig. 64 p. 79 shows a tall arrangement composed as I described earlier of blue flowers. In this composition some of the flowers faded very quickly, so the more perishable varieties were painted first, and the longer lasting specimens were left until later.

The landscape painter can generally count on his subject remaining stable much longer. He has only the weather to contend with. As a rule the portrait painter and the non-figurative painter have complete control over their painting situation. The flower painter is compelled by the transitory nature of his subject to invent a method of working in which speed is possible, especially if he is working on a large scale.

The light factor

Flowers are alive. They are highly sensitive to light. For instance the anemone, even when cut, will close at night and open during the day, and will even vary in accord with the intensity of the daylight. Lupins literally move. In hours, if not minutes, they twist themselves towards the source of light. If they could be watched by a time-phase camera they would be seen to be writhing like snakes.

The flower painter is forced into certain procedures by the nature of his subject matter. My method, as I have demonstrated in the Step-by-Step section p. 30, is to begin by making a general statement all over the work. I then start on the less durable blooms. If some fade I replace them with other specimens of the same species, if they are available. If the light turns them into positions I do not want, I frequently pick a single bloom, hold it in my left hand, in the position I need it in the composition, and work from it in that way.

Every flower painting I produce is, to some extent, a compromise. It is always a fight against time, a struggle to maintain the *status quo* of the subject. The sunflower in Fig. 76 p. 94 was determined to look in the wrong direction, so I controlled it with guy ropes tied to the ceiling and passing round the sunflower stem. I believe the end justifies any means.

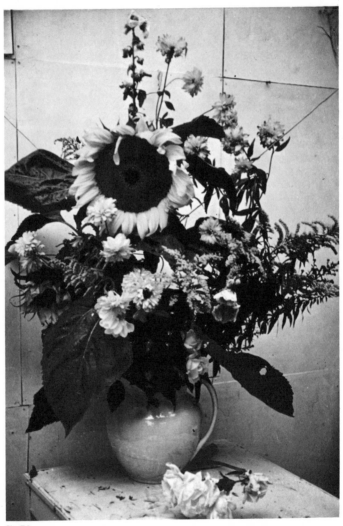

Fig 76

Framing

Artists paint pictures for two main reasons: because they feel strongly about a subject and are impelled to paint; or because they are commissioned.

Within these two categories there will be many motives and many motivations. Perhaps the chief motivation is that the artist attempts to communicate his own delight in his subject matter to other people. To do this his completed work must be seen by other people. It must be displayed—on his studio wall, on the wall of his client's home, in the board-room, in the hotel, in the gallery. It must be displayed to advantage. It must fit with its surroundings. The frame plays an important part in this.

The appropriate framing of pictures is an art in itself. It calls for subtle judgement and experience. It calls for a developed sense of visual harmony such as was discussed on p. 34. It is not possible or desirable to lay down rigid rules; but there are certain general principles which should be remembered. For instance:

The frame must suit both the picture and the setting into which the picture is placed. It would be inappropriate to put a picture with a modern metal frame into a Jacobean setting. It would be equally inappropriate to hang a picture with a large ornate frame in an exhibition in which all the other pictures had simple 'bagette' (lathe or strip) frames.

The frame should provide a tidy finish to a canvas. It should, as it were, lift the picture away from the wall, and yet make the picture part of the wall.

Avoid extremes. Do not use frames which are too ornamental, too heavy or too frail, too dark or too light in tone, or too bright in colour. In Britain many national exhibition organisers state that unsuitable frames will jeopardise a picture's chances of acceptance.

It is better for the frame to be unobtrusive rather than agressive.

If you need to paint the frame, select a neutral colour which appears in the painting and use that. If you can find a colour which appears in both the picture and in the colour scheme of the room in which the picture is to be hung, so much the better.

The fashion today is for minimal frames or no frame at all. In a modern setting, against a white wall for instance, an unframed painting on canvas can look very 'distinguished'. Silver-coloured metal strip is a popular contemporary framing material. It provides a tidy finish and is unobtrusive.

Planed white-wood lathe $\frac{1}{2}$" by $1\frac{1}{2}$" as in Fig. 79 is a simple

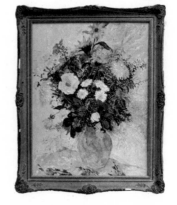

Figs 77 and 78

and acceptable type of surround. The natural colour of the wood is a good complement to many paintings; and where necessary a wipe-over with a cloth dipped in flat white paint will 'cool' the wood colour. In the same way a wipe of warm paint will enrich it.

It is not a good idea to buy old frames and think that these will do. They will not. They will *look* secondhand, and they are almost certain to be old-fashioned. It is sometimes possible to soak the old gilt or gesso covering off very ornate frames and to scrape them down and repaint them, but it is a tedious business.

Don't spoil a good painting with a poor frame. It is worth the money to go to a good framer, but make sure he is good. If you can't afford a good frame, play safe and go for an unobtrusive one.

A useful exercise in this connection is to visit your local gallery and look at the frames rather than the pictures. Then go to your picture dealer and do the same, and notice the differences. Fashion plays a big part in picture framing. The Victorians thought as much of their fancy gold-leafed and curiously carved frames as they did of the pictures in them.

Today the keyword is simplicity and unobtrusiveness.

Fig 79

Fig 77 shows our step-by-step painting in a plain 'swept' frame of medium tone. Fig 78 shows a Dutch frame of more elaborate design and 'heavier' in tone. Compare these with the simple lathe surround in Fig 79, which shows the painting hanging in my hall at home. Which do you think looks best?

Flower painting and personality

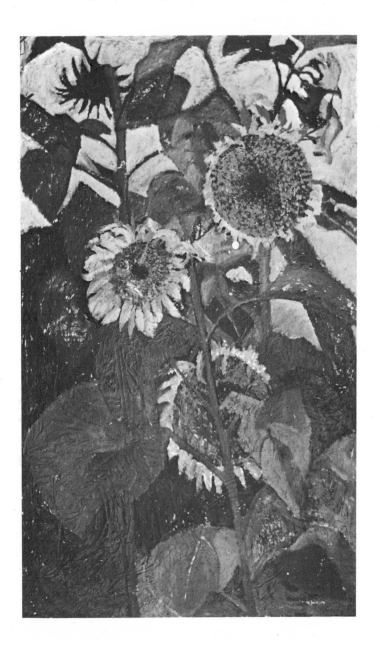

Figs 80 and 81
How far does painting reflect personality?
The sunflower in Fig 80 is 60″ x 36″
The sweet-pea in Fig 81 is 12″ x 10″
The powerful sunflower was painted by a small shy girl, the modest posy by a
six-foot extrovert male

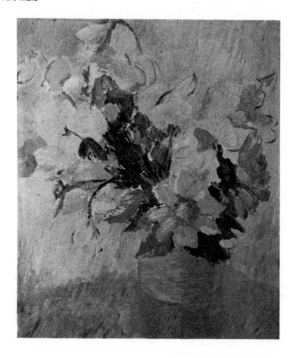

Titles

The giving of titles to pictures is not affectation. It is a practical device to help identify one work from another. If you have been painting for any length of time you will have accumulated a fair number of pictures.

If you are keen, say, on painting spring flowers, the title *Daffodils 1966* will be a positive label for that work and will avoid confusion, especially when submitting works for exhibition. It is essential that pictures should be given titles to enable exhibition catalogues to be prepared.

I prefer to use the plainest possible titles, so long as they are clear and unambiguous. I have a feeling that the title has a subtle influence upon the way people react to your work. Over-elaborate or effusive titles are not helpful.

I remember an artist friend in Yorkshire. He had a good sense of humour. His still-life of a pot of sweet-peas was being hung in the local exhibition. 'What's the title?', somebody asked him. He laughed good-humouredly and answered, 'July Jugful'.

Conclusion

We hear a good deal these days about the 'throw-away' line of the comedian; the 'throw-away style' of a speaker. In a sense the flower painter must employ a 'throw-away technique'. Many flower paintings are killed by over-working, over-emphasis, over-statement. None is ever ruined by over-observation of the subject matter before the work starts.

A flower painting can be a significant and meaningful work of art. It can be a dreary, over-worked 'botch'. Its quality will depend upon many circumstances. Among the most important are the degree to which the artist responds to his subject matter, his visual sensitivity, and the vitality of his personal reactions as he looks at the flowers.

The decorative element is always present in the work of the flower artist. Contemporary thought in art tends to dismiss the 'decorative' as unworthy of serious consideration. On the contrary, all the great artists, past and present, make use of decoration.

At its best the flower painting can be a work of creative genius. Flower painting is totally worthy as an art in its own right.

Index